nabokov.

Soho Theatre and nabokov present

by Phil Porter

Blink had its world premiere on 2 August 2012 at the Traverse Theatre, Edinburgh with original cast Harry McEntire and Rosie Wyatt.

Soho Theatre is supported by Arts Council England. Registered Charity No: 267234

nabokov is supported by Arts Council England.

Supported using public funding by
**ARTS COUNCIL
ENGLAND**

CAST

Thomas Pickles
Lizzy Watts

CREATIVE & PRODUCTION TEAM

Phil Porter	Writer
Joe Murphy	Director
Hannah Clark	Designer
Jack Knowles	Lighting Designer
Isobel Waller-Bridge	Composer and Sound Designer
Paul Jellis and **David Luff**	Producers
Josh Roche	Associate Director
Joe Price	Touring Stage Manager

A WORD FROM THE WRITER

The basic story of *Blink* popped into my head one night a couple of years ago. Normally, it takes me a long time to invent a story that makes passable sense from beginning to end, but this one appeared pretty much fully formed. In the weeks that followed, however, I became wary of my idea. When I told people the story it sounded like a psychological thriller – a genre perhaps more suited to a film or novel than a play (in theatre 'genre' itself can be a dirty word). And the story's suspenseful nature seemed ill-suited to the skew-whiffness that tends to pervade my work whether I like it or not. I filed the idea away in my head under 'Ideas To Maybe Come Back To'.

A few months later I became a member of The Soho Six – a group of six commissioned writers that meet up at The Soho Theatre every couple of weeks. For one of our early meetings we each prepared a presentation addressing, among other things, what kind of theatre excited us most. I decided (never having thought about it so directly before) that I was most excited by small, detailed theatre about big, philosophical themes. I realised that most of my favourite theatre is very silly and very serious at the same time, daring to flirt with ridicule. I went back to the *Blink* idea. I began to think the apparent mismatch of story and style might actually become the play's strength and lead to something pleasingly semi-ridiculous.

In the past, I've shied away from writing plays that require actors to address the audience directly. It always seemed too easy a way of telling a story somehow. But as part of the Soho Six programme we were encouraged to look at the entire programme of the theatre, including as it does a great deal of comedy, cabaret and other types of live performance, and to allow ourselves to be influenced by that work. In particular, I've been influenced by the brilliant Stewart Lee, whose comedy is a powerful testament to the potential complexity of direct address. His ability to make an audience laugh at him for sneering at them for laughing at themselves for laughing at a joke that isn't even supposed to be funny is nothing if not complex.

So here it is. A small, big, silly, serious, semi-ridiculous play. I hope you like it.

Phil Porter

CAST

THOMAS PICKLES
JONAH

Thomas trained at the Rose Bruford College of Theatre and Performance, graduating in 2012. His theatre credits include: *The Merry Wives of Windsor* and *The Mouse and his Child* at the Royal Shakespeare Company and before *Blink*, he appeared in *Kes* at Derby Theatre. He has featured in *Doctors* and *Casualty* for the BBC and *Shameless* for Channel Four.
Thomas is also an award-winning playwright with his debut play *Dead Party Animals* (Adrian Pagan Playwright Award and shortlisted for Soho Theatre's Verity Bargate Award).

LIZZY WATTS
SOPHIE

Lizzy trained at the Royal Welsh College of Music and Drama. Theatre credits include: *Twelfth Night* (Filter Theatre/UK tour/Mexico); *Wasted* (Paines Plough/Camden Roundhouse and UK tour); *The Man* (Finborough/UK tour); *One Million Tiny Plays About Britain* (Latitude); *Dr Faustus* (Watford Place); *Eight* (Ringling Festival Sarasota/Tantrum); *Artefacts* (Bush Theatre/UK tour/ New York) and *The Grizzled Skipper* (Nuffield Theatre).
Television credits include: *Midsomer Murders* (ITV) and *Hidden* (BBC Wales).
Film credits include: *One In The Dark* (Waring Films); *Sprawlers* (Firesnake Films) and *Footsteps* (Random Films). Lizzy has also appeared in a host of BBC Radio projects including: *Hamlet*, *Far from the Madding Crowd*, *Proud*, *Liam*, *People Snogging In Public Places*, *The Count of Monte Cristo*, *Mountain of Light* and *Our Mutual Friend*.

CREATIVE & PRODUCTION TEAM

PHIL PORTER
WRITER
Phil's plays include *The Cracks In My Skin* (Manchester Royal Exchange, winner of a Bruntwood Award); *The Reprobates* (HighTide Festival Theatre); *Here Lies Mary Spindler* (RSC/Latitude); *Stealing Sweets And Punching People* (Theatre503/Off-Broadway) and a translation of Janos Hay's *The Stonewatcher* (National Theatre). He has edited Shakespeare's *The Tempest* and *Pericles* and Middleton's *A Mad World, My Masters* for the RSC. Phil's plays for young audiences include *The Flying Machine* (Unicorn Theatre), *Smashed Eggs* (Pentabus Theatre) and several adaptations. His opera libretti include *Doctor Quimpugh's Compendium of Peculiar Afflictions* (Petersham Playhouse), *Skitterbang Island* (Polka Theatre/Little Angel), *The Whale Savers* (W11 Opera) and *Pinocchio* (Royal Opera House).

JOE MURPHY
DIRECTOR
Joe Murphy is the Artistic Director of nabokov. Theatre as Director includes: *Virgin* (Watford Palace); *The Taming of the Shrew* (Shakespeare's Globe and touring); *Forever House* (Plymouth Theatre Royal); *Blink* (Soho Theatre/Traverse); *Symphony* (Outdoor Festivals tour); *Young Pretender* (Edinburgh Festival Fringe and UK tour); *Bunny* (Edinburgh Festival Fringe/UK tour/Soho Theatre/59E59 Brits Off Broadway Season); and *The Boy on the Swing* (Arcola Theatre).
Joe is currently Associate Director for *Wolf Hall* and *Bring Up The Bodies* (RSC).

HANNAH CLARK
DESIGNER

Hannah trained in theatre design at Nottingham Trent University and Central School of Speech and Drama. She was a winner of the 2005 Linbury Biennial Prize for stage design. Designs include: *Bank On It* (Theatre Rites, Barbican, Warwick Arts Centre); *Forever House* (Plymouth Drum); *The Taming of the Shrew, The God of Soho, Romeo and Juliet, As You Like It* and *A Midsummer Night's Dream* (Shakespeare's Globe); *London* (Paines Plough); *Blink* (nabokov, Traverse Theatre & Soho Theatre); *Motor Show* (Requardt & Rosenberg); *And No More Shall We Part* (Hampstead Theatre & Traverse Theatre); *Angus, Thongs and Even More Snogging* (West Yorkshire Playhouse); *Pericles* (Regent's Park Open Air Theatre); *Episode, Roadkill Café, Pequenas Delicias*, and *Jammy Dodgers* (Frauke Requardt & Company); *The Talented Mr Ripley* and *Under Milk Wood* (Northampton Theatre Royal); *Behud* and *Gambling* (Soho Theatre); *Eigengrau* and *2nd May 1997* (The Bush); *The Boy on the Swing, Light Shining in Buckinghamshire, Knives in Hens, Thyestes* and *Torn* (Arcola); *Be My Baby* (Derby Live); *Nocturnal* and *Big Love* (The Gate); *Bunny* and *Terre Haute* (nabokov); *Billy Wonderful* (Liverpool Everyman); *The Snow Queen* (West Yorkshire Playhouse); *Company* and *Hortensia and the Museums of Dreams* (RADA); *Proper Clever* (Liverpool Playhouse); *House of Agnes* (Paines Plough); *Breakfast with Mugabe* (Theatre Royal Bath); *As You Like It* and *We That Are Left* (Watford Palace Theatre); *The Cracks in My Skin* and *Who's Afraid of Virginia Woolf?* (Manchester Royal Exchange); *Othello* (Salisbury Playhouse); *Wuthering Heights* (Aberystwyth Arts Centre & tour); *Death of a Salesman, What the Butler Saw, Blue/Orange, A View from the Bridge, I Just Stopped By To See The Man*, and *Two* (Bolton Octagon); *The Taming of the Shrew* (Bristol Old Vic).

JACK KNOWLES
LIGHTING DESIGNER
Jack trained at The Central School of Speech and Drama.
Recent credits include: *Moth* (Hightide/Bush); *Say It With
Flowers* (Hampstead); *Yellow Wallpaper* (Schaubühne
Berlin); *The Changeling* (Young Vic; with James Farncombe);
Tommy (Prince Edward Theatre); *Reise durch die Nacht*
(Halle Kalk; Shauspiel Köln); *Blink* (Traverse/Soho Theatre);
Mark Thomas: Bravo Figaro (Traverse & UK Tour); *In a Pickle*
(RSC/Oily Cart); *Thin Ice* (UK Tour); *The Riots* (Tricycle);
Ring-A-Ding-Ding (Oily Cart; Unicorn Theatre & New
Victory Theatre New York); *Young Pretender* (Watford
Palace & UK Tour); *Victoria* (Arts Ed); *The Boy on the
Swing* (Arcola); *Imperial Fizz* (Assembly); *Room* (Tron); *One
Thousand Paper Cranes* (Imaginate Festival); *My Name Is
Sue* (Soho Theatre & UK Tour); *If That's All There Is* (UK
& International Tour); *Red Sea Fish* (59E59 New York);
Hanging By A Thread (UK Tour); *Love's Labyrinth* (Opera
Restor'd); *A Guest for Dinner* (Arts Depot).
Recent Associate credits include: *Al Gran Sole Carico
D'Amore* (Berlin Staatsoper); *The Bomb* (Tricycle); *Salt; Root
and Roe* (Donmar Trafalgar); *Die Wellen* (Shauspielhaus
Köln); *After Dido* (ENO/Young Vic).

ISOBEL WALLER-BRIDGE
COMPOSER AND SOUND DESIGNER
Isobel's credits include: As Composer and Sound Designer
Ideal World Season (Watford Palace Theatre); *Forever House*
(Theatre Royal Plymouth); *Sleuth* (The Watermill); *Mydidae*
(Soho Theatre); *Gruesome Playground Injuries* (The Gate
Theatre); *The Girl with the Iron Claws* (Soho Theatre); *Head/
Heart* (Bristol Tobacco Factory); *Blink* (Traverse Theatre/
Soho theatre);
As Composer: *Neville's Island* (Chichester Festival Theatre);
If Only (Chichester Festival Theatre).

London's most vibrant venue for new theatre, comedy and cabaret.

Soho Theatre is a major creator of new theatre, comedy and cabaret. Across our three different spaces we curate the finest live performance we can find, develop and nurture. Soho Theatre works with theatre makers and companies in a variety of ways, from full producing of new plays, to co-producing new work, working with associate artists and presenting the best new emerging theatre companies that we can find. We have numerous writers and theatre makers on attachment and under commission, six young writers and comedy groups and we read and see hundreds of shows a year – all in an effort to bring our audience work that amazes, moves and inspires.

'Soho Theatre was buzzing, and there were queues all over the building as audiences waited to go into one or other of the venue's spaces. [The audience] is so young, exuberant and clearly anticipating a good time.' *Guardian*

Over 167,000 people saw a show at Soho Theatre in the last 12 months; over 1 million since we opened in 2000.

We presented 41 new theatre shows last year alongside some of the finest comedy and cabaret in the UK.

Our pricing means that tickets are affordable and accessible; our audiences are adventurous and dynamic.

Over 8,000 people attended shows for young people and families last year.

We receive public funding BUT we contribute more to government in tax than we receive.

We create jobs and help develop the UK's talent pool in the creative industries.

sohotheatre.com
Keep up to date:
sohotheatre.com/mailing-list
facebook.com/sohotheatre
twitter.com/sohotheatre
youtube.com/sohotheatre

Registered Charity No: 267234

THANK YOU

We are immensely grateful to our fantastic Soho Theatre Friends and Supporters. Soho Theatre is supported by Arts Council England.

Principal Supporters
Nicholas Allott
Hani Farsi
Jack and Linda Keenan
Amelia and Neil Mendoza
Lady Susie Sainsbury
Carolyn Ward
Jennifer and Roger Wingate

The Soho Circle
Celia Atkin
Giles Fernando
Michael and Jackie Gee
Hedley and Fiona Goldberg
Isobel and Michael Holland

Corporate Supporters
Bates Wells & Braithwaite
Cameron Mackintosh Ltd
Caprice Holdings Ltd
Dusthouse
Financial Express
Fisher Productions Ltd
Fosters
Granta
The Groucho Club
Hall & Partners
John Lewis Oxford Street
Latham & Watkins LLP
Left Bank Pictures
London Film Museum
Nexo
Oberon Books Ltd
Overbury Leisure
Ptarmigan Media
Publicis
Quo Vadis
Seabright Productions Ltd
Soho Estates
Soundcraft
SSE Audio Group

Trusts & Foundations
The Andor Charitable Trust
Backstage Trust
Boris Karloff Charitable Foundation
Bruce Wake Charitable Trust
The Buzzacott Stuart Defries
Memorial Fund
The Charles Rifkind and Jonathan
Levy Charitable Settlement
The City of Westminster Charitable
Trust
The Coutts Charitable Trust
The David and Elaine Potter
Foundation
The D'Oyly Carte Charitable Trust
The Ernest Cook Trust
The Edward Harvist Trust
The 8th Earl of Sandwich Memorial
Trust
Equity Charitable Trust
The Eranda Foundation
Esmée Fairbairn Foundation
The Fenton Arts Trust
The Foundation for Sport and
the Arts
The Foyle Foundation
Harold Hyam Wingate Foundation
Help A London Child
Hyde Park Place Estate Charity

The Ian Mactaggart Trust
John Ellerman Foundation
John Lewis Oxford Street
Community Matters Scheme
John Lyon's Charity
The John Thaw Foundation
JP Getty Jnr Charitable Trust
The Kobler Trust
The Mackintosh Foundation
The Mohamed S. Farsi Foundation
The Rose Foundation
Rotary Club of Westminster East
Sir Siegmund Warburg's Voluntary
Settlement
St Giles-in-the-Fields and William
Shelton Educational Charity
The St James's Piccadilly Charity
Teale Charitable Trust
The Theatres Trust
The Thistle Trust
Unity Theatre Charitable Trust
Westminster City Council-West End
Ward Budget
The Wolfson Foundation

Soho Theatre Best Friends
Nick Bowers
Johan and Paris Christofferson
Dominic Collier
Richard Collins
Miranda Curtis
Cherry and Rob Dickins
Norma Heyman
Beatrice Hollond
Lady Caroline Mactaggart
Christina Minter
Jesper Nielsen and Hannah
Soegaard-Christensen
Hannah Pierce
Suzanne Pirret
Amy Ricker
Ian Ritchie and Jocelyne van den
Bossche
Ann Stanton
Alex Vogel
Garry Watts
Phil and Christina Warner
Sian and Matthew Westerman
Hilary and Stuart Williams
Soho Theatre Dear Friends
Natalie Bakova
Quentin Bargate
Norman Bragg
Neil and Sarah Brener
Roddy Campbell
Caroline and Colin Church
Jonathan Glanz
Geri Haliwell
Jane Henderson
Anya Hindmarch and James
Seymour
Shappi Khorsandi
Jeremy King
Michael Kunz
James and Margaret Lancaster
Anita and Brook Land
Nick Mason
Annette Lynton Mason
Andrew and Jane McManus

Mr & Mrs Roger Myddelton
Karim Nabih
James Nicola
Phil and Jane Radcliff
Sir Tim Rice
Sue Robertson
Dominic and Ali Wallis
Nigel Wells
Andrea Wong
Matt Woodford
Christopher Yu

Soho Theatre Good Friends
Oladipo Agboluaje
Jed Aukin
Jonathan and Amanda Baines
Mike Baxter
Valerie Blin
Jon Briggs
David Brooks
Rajan Brotia
Indigo Carnie
Chris Carter
Benet Catty
Jeremy Conway
Sharon Eva Degen
David Dolman
Geoffrey and Janet Eagland
Wendy Fisher
Gail & Michael Flesch
Sue Fletcher
Daniel and Joanna Friel
Stephen Garrett, Kudos Films
Alban Gordon
Martin Green
Doug Hawkins
Tom Hawkins
Anthony Hawser
Thomas Hawtin
Nicola Hopkinson
Etan Ilfeld
Jennifer Jacobs
Steve Kavanagh
Pete Kelly
Lynne Kirwin
Lorna Klimt
David and Linda Lakhdhir
James Levison
Charlotte MacLeod
Amanda Mason
Mike Miller
Ryan Miller
Glyn Morgan
Catherine Nendick
Martin Ogden
Alan Pardoe
David Pelham
Andrew Perkins
Fiona and Gary Phillips
Andrew Powell
Geraint Rogers
Dan Savidge
Barry Serjent
Nigel Silby
Lesley Symons
Dr Sean White
Liz Young

We would also like to thank those supporters who wish to stay anonymous as well as all of our Soho Theatre Friends.

LOTTERY FUNDED

Supported using public funding by
ARTS COUNCIL ENGLAND

nabokov.

nabokov is a theatre company based in the eastern region, dedicated to putting new writing at the heart of British culture.

Through a pioneering commissioning and creative process we challenge writers and audiences to re-invent how new writing is made and experienced.

Since 2001 nabokov has hosted an extraordinarily diverse programme of work around the UK and internationally, premiering the work of over 1,000 artists. We have produced and curated vibrant artistic events at venues and festivals around the country, as well as touring premiere flagship productions.

Previous productions include the world premieres of BLINK by Phil Porter (Traverse, Soho Theatre); SYMPHONY, a theatre/live music collaboration with composer Ed Gaughan and writers Ella Hickson, Nick Payne and Tom Wells (Lyric Hammersmith, Greenwich+Docklands International Festival, Imagine Watford and Latitude); YOUNG PRETENDER by EV Crowe (Underbelly, National Tour); the Fringe First-winning and internationally acclaimed BUNNY by Jack Thorne (Underbelly, Soho Theatre, National Tour, New York); FAIRY TALES by Jack Thorne and Arthur Darvill (Latitude); IS EVERYONE OK? by Joel Horwood (Latitude Festival, Drum Theatre Plymouth, National Tour); 2ND MAY 1997 by Jack Thorne (Bush Theatre, National Tour); ARTEFACTS by Mike Bartlett (Bush Theatre, National Tour, New York); and TERRE HAUTE by Edmund White (Trafalgar Studios, National Tour).

Ours is a writer-led theatre that embraces all the innovation, complexity and diversity of the 21st century.

For nabokov:
Artistic Director	**Joe Murphy**
Executive Director	**Ric Mountjoy**
Producer	**Paul Jellis**
General Manager	**Corinne Salisbury**
Advisory Board	**Mike Bartlett, Emma Brunjes, James Grieve, Imogen Kinchin** and **George Perrin**

hello@nabokov-online.com / www.nabokov-online.com
twitter: @nabokovtheatre

BLINK

Phil Porter

BLINK

OBERON BOOKS
LONDON
WWW.OBERONBOOKS.COM

First published in 2012 by Oberon Books Ltd
521 Caledonian Road, London N7 9RH
Tel: +44 (0) 20 7607 3637 / Fax: +44 (0) 20 7607 3629
e-mail: info@oberonbooks.com
www.oberonbooks.com

Reprinted in 2012, 2013 (twice), 2014 (twice), 2015

A catalogue record for this book is available from the British Library.

PB ISBN: 978-1-84943-485-0
E ISBN: 978-1-84943-556-7

Printed, bound and converted
by CPI Group (UK) Ltd, Croydon, CR0 4YY.

Visit www.oberonbooks.com to read more about all our books
and to buy them. You will also find features, author interviews and
news of any author events, and you can sign up for e-newsletters
so that you're always first to hear about our new releases.

Characters

SOPHIE

JONAH

SOPHIE and JONAH.

JONAH: This is a true story, and it's a love story. This is our
love story. And the first thing I want to tell you is this:
Love is not a cast-iron set of symptoms. Love is whatever
you feel it to be. Love is neither dirty nor clean. That's the
first thing and this is the second: If you ever get invited
to dissect a rabbit's eyeball while at the same time taking
apart an old-fashioned Single Lens Reflex camera, accept
the invitation. And very soon you'll see how the two
things are basically the same. The cornea, that's the front
part, that's basically the focus. The iris is the aperture,
controlling the light that comes in. The lens is the lens.
And the retina, at the back of the eye, that's the film,
receiving the image. And if you're like me you'll find that
similarity interesting, which brings me on to my third point
which is that London is a very interesting place. And you
can trust me on this because I'm not from round here.

SOPHIE: Okay, so when I'm twelve my gums begin to itch
and keep me awake at night. So I tell the dentist and she
says my teeth are overcrowded, and she'll take two out to
make room. And she gives me a choice between a local, so
a needle, and a general, meaning gas. And I'm scared of
needles so I go for the gas, which they don't do any more,
but basically they hold this mask down over your face
and you have to breathe in this stuff. And it's got a kind
of rubber taste, like an old rubber ball or something. And
as you breathe you can hear this buzz getting louder, like
a chainsaw getting closer, so I fix my eyes on this nurse
and watch as she merges into this giant picture of autumn
that covers one wall. Then when I wake up I'm okay for
a second. Until this horrible, groggy feeling hits me. And
as we leave I throw up this pool of frothy blood on the
doorstep. And we get to the car and I'm sick in the car, and
we get home and I'm sick in the porch, and I'm sick about
five times more, and it's Pancake Day but I'm too sick for
pancakes, so basically it's just a really bad experience. But
at least the itching goes away, until two years later when it

comes back, and the dentist says she'll take two more out. And again I get the choice, and again I go for gas, only this time I ask my dad if, when we get home, I can have my bed in the garden. I want to lie outside and clean my lungs in the air. And I know it's mad what I'm asking. It's not a real request, more just an idea. But when we get back my bed's there on the lawn. And this is The Isle of Man in April, so the weather's not warm. But there it is, with an extra blanket, and Winston, my bear, on the pillow. And there's even a bedside table, with fizzy water and a working lamp, and I'm telling you this so you understand the kind of man he was, my dad. He made me feel seen.

JONAH: *(Holds up a small, mud-encrusted pair of wellies.)* Welly boots.

SOPHIE: He was a tax lawyer.

JONAH: Hand-me-downs from a cousin originally.

SOPHIE: My mother lives in Malaga. She left when I was two.

JONAH: Wouldn't fit me now. Says on the sole 'Size 3'. And my name on the inside in felt tip: Jonah Jenkins. And if you're wondering why they look worn out that's because they are, and that's because I grew up on a farm. Or self-sufficient religious commune to be specific. We are The Paythorne Presbyterians. Mr Jenkins is my father and he's very much the man in charge. And every morning from six o'clock he reads to us from the Bible 'til his throat gets sore. If we snooze or fidget, an old man called Mr Fricker whacks across our knuckles with a long wood spoon. Technology's frowned upon, so there's no TV, no toaster, no microwave. Just an old green telephone for emergencies. Food is soup or stew, except on Sundays when we have roasted chicken followed by custard, and every spare minute we work the farm. So, age five I'm milking cows. Age seven catching rabbits for stew. Then age fifteen my mother Mrs Jenkins dies of pancreatic cancer. Now, it's her that's dealt with the outside world to now, and that's worked well because the outside world likes my mother. Because she's warm, unlike

Mrs Dimmock The Unfriendly Whorebag who takes over in her absence. And before long we're getting our windows smashed in at night. And our outbuildings set on fire. 'Jesus Fucks Arses' and 'Jesus Sucks Cock' sprayed on the wall of the barn in graffiti. It's decided we need a nightwatchman, a post for which I volunteer. And from that day forward, each night, from midnight 'til six, I keep watch. No stopping for tea. No falling asleep or playing with my privates. Just me and Mr Fricker's Single Lens Reflex Camera, every night for five years, me peering through the zoom, and I'm telling you this so you come to see how keeping watch, it becomes a kind of habit for me.

SOPHIE: So, The Isle Of Man isn't exactly the centre of the universe. It's a place known mostly for cats with no tails and motorbikes. And jobswise it's kind of limited beyond the financial sector. So when I finish college, Dad retires and buys a house in East London, in Leytonstone, which is where he grew up, and that's where we live. It's actually two separate flats, with me on the first floor and him underneath, with separate front doors and a shared garden. I find a job with a software company called Bunch. We design and sell collaboration and content management solutions for clients in the business market. So, that might be file-sharing apps, project management apps, video-conferencing tools, that kind of thing. I'm one of four Client Managers and I look after three main accounts: Southern Trains, Haribo Sweets and an Asian snack manufacturer called Balaji. And while I'm at work, Dad goes out and does stuff. London kind of stuff like matinees of plays, or free talks at the Royal Society. And then in the evening we cook in one of our kitchens and we talk. And everything's pretty much perfect until his face turns yellow overnight. And the whites of his eyes go yellow too, and he's diagnosed with pancreatic cancer.

JONAH: Pancreatic cancer's the first of several coincidences.

SOPHIE: He'd smoked for most of his life and that's what caused it.

JONAH: My mother didn't smoke but she did have Type Two Diabetes, which is also a known risk factor.

SOPHIE: But at first it doesn't feel real somehow. Because he doesn't seem that sick to begin with. But then he starts to age quite rapidly. And he starts getting back pain, and pain when he eats. And he gets this fever at night which gives him nightmares and makes him sleepwalk. And one night he hurts his toe on the leg of the bed, so I offer to move in downstairs with him but he doesn't want that. He doesn't want the illness to be my life, but of course it's my life. We reach a compromise and buy this thing. *(She holds up a video baby monitor.)* It's a wifi baby monitor with a video screen, so if I'm worried I can check on him. In the end he's been lying there days, not really speaking. This is in the hospice now. And I'm just sitting by the bed, watching his chest go up and down. And then, late one morning, it stops. So I think, 'Okay, so that's it then.' But then out of nowhere he's up on his feet. And he's pulling on his catheter, shouting and swearing. And a nurse is suddenly there saying, 'Don't worry, Sophie, it's not him, he's gone.' And she pushes him back down on the bed, quite hard, and now he really is gone. This happens quite a lot apparently. It's like a final bit of the person needs somehow spitting out.

JONAH/SOPHIE CATTERMOLE: Can I get you something to drink?

SOPHIE: *(Caught between worlds, as if waking up, in a cloud of grief.)* Sorry, what?

JONAH/SOPHIE CATTERMOLE: Coffee, water, tea? Something herbal?

SOPHIE: No, thank you.

JONAH/SOPHIE CATTERMOLE: You are Sophie Kissack? I'm another Sophie, Sophie Cattermole.

At various points, JONAH and SOPHIE stand in as other characters, but without necessarily transforming themselves or fully playing

these characters. If there's a brief moment of confusion at the point of transition, all the better.

JONAH/SOPHIE CATTERMOLE: I'm Acting Head of Personnel while India's on maternity. And you've been off for a couple of weeks, is that right?

SOPHIE: That's right.

JONAH/SOPHIE CATTERMOLE: Good to have a break, did you go somewhere nice?

SOPHIE: My dad died.

JONAH/SOPHIE CATTERMOLE: Where, sorry?

SOPHIE: I said my dad died.

JONAH/SOPHIE CATTERMOLE: I'm so sorry, I wasn't told. Or rather I was told, I was told you were on holiday.

SOPHIE: It's fine.

JONAH/SOPHIE CATTERMOLE: Has the funeral been and gone or is all that still to come?

SOPHIE: It was last week.

JONAH/SOPHIE CATTERMOLE: Then I guess that's one thing out of the way at least. How's it left you feeling? *(No response.)* Pretty numb, I should think. Did he pass away suddenly or had he been ill a long time?

SOPHIE: He'd been ill a few months.

JONAH/SOPHIE CATTERMOLE: Okay, so you got a chance to say goodbye at least. Though that can be very upsetting in itself, of course. My stepfather died last year. He had a series of mini-strokes and then a very big one. It's still hard to believe he's gone. Sophie, I'm in a position now where I have to tell you something. And given what I now know, and how much it's clearly upset you, it's something I feel awful saying. But this is my job so I'll have to just say it. There was a meeting last week and you're being let

go. Your rolling contract won't be renewed at the end of the month. *(No response.)* Now, this might sound strange, but I'm wondering if this might be good news I'm giving you. I don't know if you believe in funny little signs from the gods. But I'm wondering if this might be one of those. A nudge from the Gods to give yourself time. To heal and start anew and that kind of thing. Do you have any kind of partner to lean on?

SOPHIE: No.

JONAH/SOPHIE CATTERMOLE: Okay, well, perhaps that's a good thing too. If time and space is what you need. I actually had a similar thing happen to me when I was your age. I was a speed-skater back then, astonishingly. And I got picked for the Winter Olympics in Salt Lake City. And I got through my heat, just, but then I got an elbow from this very large Dutch girl in the semi-final. And I fell and broke several bones in the middle of my foot. I had to give up skating. And it was like I'd lost my purpose is the only way I can think to describe it. I got depressed, I put on weight, I wouldn't leave the house. I developed this weird panic disorder where my mouth would lock shut whenever the phone rang. But all that seems a lifetime ago now. Because time's a great healer. Now I have a husband, a beautiful daughter called Emma, this great career. I'm slim again, my foot's all better –

SOPHIE: Sorry, can you just stop talking for a second, please?

JONAH/SOPHIE CATTERMOLE: Of course.

Silence.

SOPHIE: So, is it just me or all four of us being let go?

JONAH/SOPHIE CATTERMOLE: I'm afraid it's just you.

SOPHIE: Did I do something wrong?

JONAH/SOPHIE CATTERMOLE: It's a money-saving thing.

SOPHIE: There must be some reason though. Why they chose me and not the others.

JONAH/SOPHIE CATTERMOLE: I suppose, looking at the four of you, the execs just felt...

SOPHIE: Go on.

JONAH/SOPHIE CATTERMOLE: I guess they just felt that you were the one least here. Even when you are if that makes any sense.

SOPHIE: Not really, no.

JONAH/SOPHIE CATTERMOLE: There's a feeling you're not always present. That you can disappear.

SOPHIE: What, because I don't go to the pub after work?

JONAH/SOPHIE CATTERMOLE: No, it's more just a...

SOPHIE: What?

JONAH/SOPHIE CATTERMOLE: More just a general perception. That you lack...

SOPHIE: Lack...?

JONAH/SOPHIE CATTERMOLE: Visibility. Or that's what it says on the piece of paper. There's a general perception that you lack visibility.

SOPHIE: Thank you. *(Gets up, goes somewhere, does something.)*

JONAH: *(Digging in some soil with a trowel.)* The day following my mother's death I get a letter in the second-class post. And I know it's from her from the handwriting. But I don't open it because once it's open that's her dead forever in my mind. But while there are words that stay unspoken she can't be dead, or so it seems to me. So there it sits for three-and-a-bit years, on a shelf between The Common Book Of Prayer and a book of knock-knock jokes, until one night in April when I just think 'fuck it'.

SOPHIE/MRS JENKINS: *(Reads from letter, still primarily in a haze of grief and confusion.)* 'My darling Jonah.'

JONAH: And straight away this is abnormal. For her to use a word like 'darling' is abnormal.

SOPHIE/MRS JENKINS: 'Please don't waste your life like I have. There's more to life than milking cows and clearing out their shit.'

JONAH: And if 'darling' was a shock, 'shit' is an even bigger shock.

SOPHIE/MRS JENKINS: 'Every day can be different if you want it to be.'

JONAH: This from a woman who wore the same skirt every day of my life.

SOPHIE/MRS JENKINS: 'Go somewhere. Do something with your life. Your father's had his own way a long time now.'

JONAH: Well, this is true.

SOPHIE/MRS JENKINS: 'Do me proud, my beautiful boy. With love from Mrs Jenkins brackets Mum.'

JONAH: Then, finally, this:

SOPHIE/MRS JENKINS: 'PS: I've saved up some money to get you started. Just a few pence here and there over the years. Buried behind what was the old cowshed.'

JONAH: *(Digs with added purpose.)* I take a good-size trowel and a bike light for a torch. There's no 'x' to mark the spot, but there's a patch of bare mud where all around is grass, so that's where I dig. And it's a starry old night. And all around the owls terwit-terwoo. But my heart pounds fast as I dig and dig and keep digging 'til finally I hit on something hard.

He pulls an old weekend bag/vanity case out of the ground.

JONAH: A small red suitcase for ladies. And inside…

He snaps open the weekend bag/vanity case and shines the light inside.

JONAH: Twenty-seven thousand, four hundred and nine pounds eighty.

SOPHIE: I inherit both flats and some money.

JONAH: That we should both inherit money's another coincidence.

SOPHIE: *(Looks into a full-length mirror.)* I stay upstairs and decorate downstairs to maximise the rental potential. Paint the walls white and re-tile the bathroom with instructions from the internet.

JONAH: I walk the four miles to Barnoldswick and buy a bacon sandwich for a pound-eighty.

SOPHIE: I bag up my dad's stuff and take it to a charity shop. And I pay a man called Archie to fix the water pressure.

JONAH: After the sandwich I have twenty-seven thousand, four hundred and eight pounds exactly.

SOPHIE: I develop this weird feeling under my lungs, like a fir cone, lodged.

JONAH: I catch a bus to Skipton, a train to Leeds and a train to London Kings Cross.

SOPHIE: And I notice something weird in the mirror. When I look at myself I can see myself like normal. But after a few seconds it's like I start to fade. And I can see through to what's behind. It's like I'm disappearing. It's the same if I stare at my hand, it's like it fades. I start to think about what the other Sophie said, about how I lack visibility, and I notice other things. Like at the shop I'll stand at the counter. But the woman won't look up. So I'll drop a coin to make a noise, and now she does look up. But kind of through me for a second. Like I'm only slowly coming into focus. Then one day I'm on the tube and a man sits on me. Sits on me like I'm an empty seat. Then jumps up when he feels me there. Stares at me like I'm a ghost. A leaflet

27

comes through from The Royal Society. About an event coming up called Ships That Appeared To Disappear. So I go along, thinking maybe it's a Sign From The Gods. But it's not. It's a lecture on maritime navigation in the time of Charles The First.

JONAH: Black people have black blood and it's the blackness of the blood that colours the skin. This is what I was always taught. So it's a shock, at London Kings Cross, to see a man with red-coloured blood dripping from a cut in his black-coloured forehead. And it's dribbling out fast, getting on the cuffs of his suit which looks new, so I offer a tissue to hold against the cut. Then, when the bleeding stops, I ask the man where's good to live in London. And he says: Leytonstone.

SOPHIE/CHARLOTTE: *(In a car with JONAH.)* How do you feel about Portuguese food?

JONAH: *(Caught between worlds.)* I don't know what you mean.

SOPHIE/CHARLOTTE: Portuguese food. Chourico, bacalhau? Custard tart?

JONAH: I like custard.

SOPHIE/CHARLOTTE: Okay, if you follow this road to the end you'll hit the High Road. Do a right, then fifty yards down there's a place called Palmeiro. It's like a family-run Portuguese Café. With a shop at the back selling stuff like biscuits and oil.

JONAH: Okay.

They sit without talking for a few seconds. We are in a car.

SOPHIE/CHARLOTTE: So, one-beds round here go for about a thousand a month. So that's sort of what you're looking at.

JONAH: 'Like a gold ring in a pig's snout is a beautiful woman who shows no discretion.'

They sit in silence for a few seconds.

JONAH: 'Like a gold ring in a pig's snout is a beautiful woman who shows no discretion.'

More silence.

JONAH: Sitting in the car of the lady estate agent, I repeat in my head these words from the book of Proverbs to stop myself getting an erection. Her name's Charlotte. She has curly red hair and smells like a tomato plant, with joined-up freckles on the skin above her tits. I choose a furnished ground floor flat for one thousand and fifty a month.

SOPHIE: When the work on the ground floor flat's all done I sign it across to a management company.

JONAH: I pay Charlotte seven thousand three-hundred pounds from the red suitcase.

SOPHIE: I spend my time listening to classic audio books and playing Xbox. I mostly play a game called Red Dead Redemption: Undead Nightmare.

JONAH: Charlotte goes but leaves her smell, then five minutes later that's gone too.

SOPHIE: The gamer plays John Marston, a man looking for a cure to a badly infectious zombie plague that's sweeping the Wild West. He needs to find it before his wife and son are lost to the plague forever. You're given various weapons, including a blunderbuss, which you can fill with zombie body parts and use to kill more zombies. And there are zombie animals to kill, like zombie cougars and bears. It's known for its high body count.

JONAH: I establish a daily routine around three main events. The first is to feed the old fox that comes in the garden. I call him Scruffilitis on account of his back half being bald from mange. Each morning I put his food down, go inside and watch him eat. Then when he's done he presses the sore skin against the back door window to cool. And I touch the other side with my fingers, hoping to heal, like Jesus to a leper.

SOPHIE: I regret giving my dad's stuff away. Stuff like his old green coat, which I didn't like when he was alive, but I miss it now. But everything's gone from the charity shop so I start buying new stuff. Not like for like, just stuff that reminds me of him. Second-hand stuff off the internet mostly. It feels good getting post every day. And seeing my name in a stranger's handwriting feels good too. But when I open the packets, the stuff I've bought tends to seem quite random. Like a hundred vintage marbles. Or a machine for shaving the fuzz off jumpers. So I keep these things in a box in the corner.

JONAH: The second main event of the day is lunch, for which I go to the Portuguese café.

SOPHIE: I also start smoking, which is deeply weird. And I start buying crystals and stones with supposedly magical powers.

JONAH: I order two roasted chicken sandwiches and two custard tarts, eating one of each and taking the others home for later. And I buy a small chunk off the big sausage for Scruffilitis next morning.

SOPHIE: I bite my nails and when my nails are gone I bite the skin from my fingertips.

JONAH: The third main event is a bath which I take in the dark at nine.

SOPHIE: I trim my fringe with a pair of nail scissors.

JONAH: I buy sheets and pillows but find I sleep better in a chair.

SOPHIE: I stop answering the phone and find it hard to fall asleep.

JONAH: I measure the size of each room in foot-lengths.

SOPHIE: I order my food online and generally eat standing up.

JONAH: I feel quite lonely and sometimes think about going home. I send my address but no one writes and no one comes.

SOPHIE: I feel quite lonely and sometimes think about killing myself.

JONAH: I get a large padded envelope in the post addressed to 'occupier'. *(He takes the wifi baby monitor screen from a padded envelope.)* Inside is a small screen, not ten inches across, and a plug to plug it in with. And on the side a small green button which I press…

We hear a double beep come from somewhere near SOPHIE. She is standing in her pyjamas. She has a green apple in her hand. JONAH watches her on the screen…

JONAH: …and onto the screen comes a girl. Stood very still with an apple in her hand. *(Taps the screen.)* Hello?

He watches her do nothing for a few seconds, then she lifts her empty hand and rubs her face with it.

JONAH: She does nothing for a while, then lifts her empty hand and touches her face with it…

A couple more seconds of nothing. Then she takes a deep breath, almost like a sigh.

JONAH: …then takes a deep breath, almost like a sigh…

She lifts the apple to her mouth.

JONAH: …before lifting the apple to her mouth. But she doesn't bite it straight away, just holds the skin against her lips…

She holds the apple by her mouth for a moment then takes a bite.

JONAH: …then she does take a bite…

She chews it slowly.

JONAH: …chews it slowly, maybe nine or ten times…

She swallows.

JONAH: …before swallowing. Tucks a piece of hair behind her ear…

She tucks a piece of hair behind her ear and sits down.

JONAH: …sits down…

He watches her do nothing for a few seconds.

JONAH: …does nothing for a while, then takes another bite…

She takes another bite and chews it slowly.

JONAH: …again chews it slowly, maybe nine or ten times…

She swallows.

JONAH: …before swallowing.

SOPHIE: I'd seen him in the garden. Putting out scraps for the sick fox that sleeps behind the shed. And I remember, as he bent down with the plate, how he kept a hand behind his back, which is how my dad used to stand, with a hand behind his back like a butler. But as for the having of the idea, and the actual packaging and sending of the screen, all that happened in a kind of foggy haze. So when the camera beeps to life it's a shock at first.

We hear the double beep again and see SOPHIE's first few moments on the screen again…

SOPHIE: …and I just stand there frozen at first, to the spot, thinking 'okay'. And I'm thinking I should do something natural-seeming, so I rub my face with my hand.

She lifts her empty hand and rubs her face with it.

SOPHIE: And there's an apple in my other hand, so I lift it to my mouth…

She lifts the apple to her mouth and holds it there for a moment.

SOPHIE: ...but my adrenalin's pumping so hard I can't actually physically open my mouth for a second. But then I do. And as I swallow it's like I swallow my nerves away. And I'm left with a new kind of feeling. Like the fog's beginning to clear.

She continues to eat her apple, enjoying herself now, relaxed...

JONAH: *(Staring hard at the screen, watching her.)* As a child I developed an unholy fascination with pillar boxes. I'd walk the long way to school to see as many as I could. And some days I'd disappear from class, to be found with my arms around the VR Type B box by the school gate. And for this I'd be told I was bad, and have my bare arse spanked by Mr Fricker 'til the thought of a pillar box brought just as much shame as delight. With these two feelings of shame and delight once again doing battle, I observe this girl in her home. And I'm positive she doesn't know she's being watched, but that only makes it worse somehow. *(Puts the screen aside.)* I put the screen aside and turn to the Bible, as would my mother at a time of moral crisis. *(Picks up a Bible.)* I ask of The Book, 'Is it wrong to watch a person without their knowing?' *(Opens Bible and points randomly.)* I'm taken by the Lord to The Song Of Solomon, Verse Three, Chapter Nine. *(Reads.)* 'King Solomon made himself a chariot of the wood of Lebanon.' On this basis I decide that God has no strong opinion on the matter either way. I limit myself to a quick look every two hours at first. But this soon becomes one long look that lasts the whole day. And soon, though I don't know who or where she is, I feel closer to her than I ever felt to any other living soul.

SOPHIE: Being watched makes doing things more attractive somehow. Just simple things.

JONAH: We sit and read books together, drink simultaneous cups of tea, do our exercises together –

SOPHIE: I find I can listen to music again. It's like there's new space in my head.

JONAH: So we do, we listen to music together. And radio programmes. Eat our meals at the same time, do our housework simultaneously, take naps together. I watch her play computer games –

SOPHIE: It's like if you ever had a brace with a plate, a retainer? And you get used to it, don't you? But then you take it off for a party and suddenly the top of your mouth is massively sensitive. And a slice of cake or even just the roughness of your tongue against it becomes this massively ticklish experience. *(Switches on TV.)* Like someone messed with the controls and turned up the contrast.

JONAH: We have a programme we watch at five-thirty on weekdays. It's a drama programme with characters of all ages, but we like the young ones best.

SOPHIE: So, lately there's been this massive love triangle storyline. Andrew and Natasha have been together a while but he wants to be with Summer, which is fair enough because Tash is pretty but shallow while Summer's lovely, if a bit serious.

JONAH: Summer likes him too and they indulge in sexual intercourse in Summer's bedroom at Number 26.

SOPHIE: This is especially massive because it's Summer's first time.

JONAH: But while the act of infidelity is taking place the house catches fire.

SOPHIE: Which is funny because it feels like the house catches fire from the sex, even though it's really just the Christmas lights. Anyhow, Tash is first on the scene and goes in to save Summer.

JONAH: Not knowing her beloved's in there too, in bed with her so-called friend.

SOPHIE: And you're thinking she's going to see them together and leave them to burn.

JONAH: But before she reaches the bedroom she collapses from the smoke and nearly dies.

SOPHIE: So, afterwards, Andrew and Summer feel really bad, and they decide not to tell Tash they're in love.

JONAH: At least until the wound on her neck gets better, which might never happen.

SOPHIE: But it does and they're just gearing up to come clean when Tash sees them kissing in the kitchen of Number 22.

JONAH: But she doesn't say she's seen them. Instead, she tells a lie and says she's having Andrew's baby –

SOPHIE: To punish him, but also to keep him.

JONAH: And you're shouting at the screen, 'It's not true, there is no baby,' but they can't hear.

SOPHIE: *(Starts taping up the box in the corner.)* So Andrew says he'll stick with Tash and bring up the baby –

JONAH: Which doesn't exist –

SOPHIE: …and he starts taking the whole thing dead seriously, working extra shifts and buying baby strollers. It's actually quite cute.

JONAH: Until Summer begins to suspect Natasha might not really be with child.

SOPHIE: So Tash buys this fake scan online to keep her quiet.

JONAH: But Summer proves the scan's fake so Andrew ends his relationship with Natasha.

SOPHIE: But Summer and Andrew's moment's sort of gone by this point. There's nothing stopping them being together now. But it's like the planets or the stars aren't aligned for them any more. Which is kind of tragic and strangely believable if you ask me. *(Switches off the TV.)*

JONAH: You didn't need to know any of that. By which I mean, the story of our programme's very different to the story of us. It's just one of the things we like to do together.

SOPHIE: *(Taping up the box.)* The box of random items stares at me accusingly from the corner of the room. *(Picks the box up.)* So, even though I only bought the stuff to replace the other stuff. And even though some of it was actually quite expensive –

As she carries the box its bottom gives way, spilling its contents (jumper fuzz machine, several hundred loose marbles, Polaroid camera, books, Lego, framed photo of old footballer, several old doorknobs, a novelty cruet set, etc, etc.) across the floor. This makes a massive noise as the items land and bounce and roll about on the floor above JONAH's head. He looks up at the ceiling and puts two and two together.

In this way her whereabouts become apparent to me.

SOPHIE: Which is fine, it was bound to happen someday. But what happens next does piss me off because now he starts following me places. To the shop when I go for cigarettes, which, again, is fine, but was never the idea. The idea was the camera: detached, simple, indoors. Not to have some random boy diving behind a wheelie-bin when I turn my head in the street.

JONAH: I dress inconspicuous so as not to be too obvious.

SOPHIE: But he's massively obvious and it does piss me off and I think about ending the whole thing. Unplugging the camera, telling him to leave me alone. But I don't. And with time I do soften to this new way of being. Start to find it almost funny. It's like I've got this comedy cartoon spy on my tail, tripping over cats and kicking milk bottles over. And before I know I'm actually taking him places on purpose. To the library to pick an audio book, or browsing round the pound shops.

JONAH: And I'm positive she doesn't know I'm there. Because not once does she look round.

SOPHIE: Because I don't need to. I can feel him there, like at home. We start going on these mini-dates, don't we?

JONAH: Just locally at first.

SOPHIE: Feed the ducks in the lake by the hospital. Sit in the park by the bandstand.

JONAH: Buy a cup of tea, watch the world go by.

SOPHIE: Then we get braver, start going into town.

JONAH: Travel by underground. Different sections of the same carriage.

SOPHIE: We keep to public, outdoor-type things for a while. But then a change in the weather forces us indoors and we start going to galleries.

JONAH: Circling these big old rooms full of pictures, never looking at her, just tracking her by sound and smell.

SOPHIE: What else?

JONAH: We go on bus rides, me sat a few rows behind.

SOPHIE: We go to the museum of the British Dental Association, which I can recommend.

JONAH: We go to the pictures, sit in the same dark room.

SOPHIE: Go for coffee.

JONAH: Go for meals.

SOPHIE: Sushi works well. Something about choosing from the same plates, even though we're a distance apart...

JONAH: ...and how each plate on the belt goes near us both...

SOPHIE: ...and it's the conveyor belt that makes me think of the London Eye, which I thought you had to book but it turns out you don't, or not always. Because we take a look one evening and there's no queue, and we end up on the last pod of the day.

JONAH: Just us and two others. A boy and a girl –

SOPHIE: Spanish –

JONAH: …who start kissing as soon as the door shuts, and keep it up the whole way round –

SOPHIE: Which is sort of understandable because they're weirdly good-looking. Like models –

JONAH: …while we sit either ends of the bench, look out across London as the sky grows dark. *(He edges closer to SOPHIE.)*

SOPHIE: *(Anxious.)* I focus on the view, which is beautiful, obviously, it's what you'd expect. The bridges, Saint Paul's, Tate Modern…

JONAH: Everywhere you look lights are coming on. Turning London from a normal place into a sparkling romantic wonderland. *(He edges closer to SOPHIE.)*

SOPHIE: *(Stands, moves away.)* This feels like a mistake. Too much too quick I'm not ready.

JONAH does nothing for a moment, then gets up and stands a few yards from SOPHIE.

SOPHIE: But in the reflection I can see the Spanish kids. Each with a hand in the other's hair. And she's kneading his arse like dough with her other hand. Their tongues pressed against each other. And he's got a hand between them, bending his knuckles, giving her something hard to rub against. *(She moves closer to JONAH.)*

JONAH: She moves near. I stand my ground, grip the handrail.

SOPHIE: And there we stay for the rest of the way round.

JONAH: Heart banging loud through my head like a mallet.

SOPHIE: Looking west.

JONAH: Close enough to hear the breath of her.

SOPHIE: Sinking slowly down towards the river.

JONAH: Close enough to appreciate the smell of her.

SOPHIE: And I look down at my left hand, less than a metre from his. And I stare and I stare but it goes nowhere. It remains. Visible. But giving up grief's like giving up anything. When you start to think the battle's won that's when you're most exposed. I get home to a message from a company called Cluster. They're similar to Bunch but with more of a public sector focus. They have a vacancy to which they think I'm suited.

JONAH: I can tell it's an interview from the make-up and clothes, and the speed of the walk.

SOPHIE: They're on Hanbury Street, off Brick Lane, so it's Central Line west to Liverpool Street, then a ten minute walk back east. I'm early but there's a café next door.

JONAH: I wait forty-five seconds then follow her in.

SOPHIE: I order coffee but don't drink in case I start to sweat.

JONAH: She sits by the window. I sit two tables behind.

SOPHIE: The café's not busy but there's noise from the coffee machine.

JONAH: The normal whooshing sounds.

SOPHIE: And there's music playing through speakers.

JONAH: I order a large cup of tea and a slice of banana cake.

SOPHIE: I check my make-up, go over my notes.

JONAH: I pick up a newspaper.

SOPHIE: I feel a bit sick so I suck on a mint.

JONAH: I read a story about a kitten born with two faces.

SOPHIE: Then a flash of colour outside makes me look up. And outside the café…running by…in his old green coat… it's him. It's my dad.

JONAH: Her chair falls back as she stands up suddenly.

SOPHIE: Run out into the street.

JONAH: I take her bag and keys and follow.

SOPHIE: And I see him go left at the end of the street so I chase.

JONAH: And I see her go left at the end of the street so I chase.

SOPHIE: And it's busy but I can see him still and it's him, it's definitely him –

JONAH: And I'm thinking, 'What am I doing? I'll give myself away.'

SOPHIE: And it's a shock but it's not because I knew he wasn't dead, I knew –

JONAH: But then I'm thinking, 'No, this is good, this is how we meet for real.'

SOPHIE: Because it never felt real, you know? But this, this is real –

JONAH: And I'm thinking, 'Maybe she's running cos she knows I'm chasing.'

SOPHIE: Take off my shoes.

JONAH: But I don't care because this is how we meet for real, this is it, the keys, the bag –

SOPHIE: And I shout 'Dad' but I hardly make a sound.

JONAH: And I shout 'wait, stop' but she doesn't hear, but it doesn't matter cos I'm closing cos she's slowing –

SOPHIE: And he's slowing so I'm closing 'til a group of kids with clipboards block the way.

JONAH: Lady postman with a trolley full of post.

SOPHIE: Push past.

JONAH: Push past.

SOPHIE: Push past.

JONAH: Push past, and I'm tasting the blood in my throat now.

SOPHIE: Reach a crossroads. Dad runs across, I follow.

JONAH: Runs out into the road.

SOPHIE: *(Calls out.)* Dad.

JONAH: *(Calls out.)* Stop.

> *A screech of brakes and the sound of van on person, followed by the sound of person on road. JONAH gently scrapes SOPHIE up and puts her in a hospital bed, attaching tubes and electrodes to her limp body...*

JONAH: People aren't heavy they're light. She flies through the air, blown on the wind like a carrier bag, lands face down. First to her's a man in a green overcoat who takes out his phono. Three people climb from the van. First a girl with her face painted green. Then two boys, one painted red, one orange. I go in a shop, buy one-point-five litres of cream soda, then when I come back the ambulance is just arriving. They strap her down and slide her in. Then time bounces forward an hour and I'm turning a key in a lock, letting myself in her flat.

> *He enters her flat, looks around.*

JONAH: And it's funny how a place can look bigger on screen. Even when the screen's no bigger than a face flannel.

> *He sits where she sits and switches on the TV.*

JONAH: I sit where she sits and watch our programme. Natasha's father, the school headmaster, is accused of letting personal grudges affect his decision on the school catering contract.

The phone rings. JONAH switches off the television and answers it.

JONAH: *(Picks up.)* Hello?

SOPHIE/MR SHUTTLEWORTH: Hello, is that Mr Kissack?

The actor plays SOPHIE and MR SHUTTLEWORTH at the same time. So she speaks MR SHUTTLEWORTH's words from her hospital bed in which she lies in a comatose state.

JONAH: No.

SOPHIE/MR SHUTTLEWORTH: Is this the number for Sophie Kissack?

JONAH: Yes.

SOPHIE/MR SHUTTLEWORTH: Who am I speaking to, please?

JONAH: She's not here, I'm afraid.

SOPHIE/MR SHUTTLEWORTH: Is that her partner?

JONAH: That's right.

SOPHIE/MR SHUTTLEWORTH: And your name is?

JONAH: Jonah.

SOPHIE/MR SHUTTLEWORTH: Okay Jonah, I'm Mr Shuttleworth. I work as a trauma consultant at the Royal London Hospital in Whitechapel. I'm afraid Sophie's had an accident.

JONAH: Okay.

SOPHIE/MR SHUTTLEWORTH: Quite a serious one, I'm afraid. She's still alive.

JONAH: Okay.

SOPHIE/MR SHUTTLEWORTH: But she's very poorly indeed. She was hit by a van.

JONAH: Okay.

SOPHIE/MR SHUTTLEWORTH: She's in the Trauma Centre at the Royal London on Whitechapel Road. If you come in I can explain more once you're here, okay?

JONAH: Okay.

SOPHIE/MR SHUTTLEWORTH: If you come by tube we're right by the station.

JONAH: Okay.

SOPHIE/MR SHUTTLEWORTH: Just go to the desk and say Mr Shuttleworth's expecting you. Bye then, Jonah.

JONAH: Bye then.

JONAH joins SOPHIE and MR SHUTTLEWORTH at the hospital.

JONAH: Mr Shuttleworth talks me through the damage. She has suspected fractures to the right midfoot and a multiple fracture of the right ankle.

SOPHIE/MR SHUTTLEWORTH: She also has a double fracture of the left hip and her pelvis is broken in three places, with additional ligament damage…

JONAH: The kneecap on her left leg's in the wrong place.

SOPHIE/MR SHUTTLEWORTH: She's broken the fourth and fifth finger on her left hand and suffered some nasty burns to her bottom and shoulders.

JONAH: She also has a variety of scratches and bumps…

SOPHIE/MR SHUTTLEWORTH: The worst of which is on her head, which is why she's currently in a coma. *(He lets this sink in.)* The van that hit her was full of actors, apparently. On their way to a school to perform a play about road safety. Do you know what I mean by the letters GCS, Jonah?

JONAH: No.

SOPHIE/MR SHUTTLEWORTH: GCS is the scale we use to record the extent of a patient's consciousness. It stands for Glasgow Coma Scale.

JONAH: Okay.

SOPHIE/MR SHUTTLEWORTH: It's pretty simple really. The patient's given a score in relation to three separate criteria. The scores are then put together to make an aggregate score out of fifteen, with me so far?

JONAH: I think so.

SOPHIE/MR SHUTTLEWORTH: The first criteria we call 'E' or 'Best Eye Response'. For one point we have no response, for two the eyes open in response to pain, for three in response to speech, and for all four points they open spontaneously, like yours or mine. Squeeze her fingernail, see what you get.

JONAH squeezes SOPHIE's fingernail.

SOPHIE/MR SHUTTLEWORTH: Bit harder.

He squeezes a bit harder.

SOPHIE/MR SHUTTLEWORTH: So, the eyes stayed shut so that's one point.

JONAH: Like cricket scoring.

SOPHIE/MR SHUTTLEWORTH: Do you play cricket?

JONAH: Not really.

SOPHIE/MR SHUTTLEWORTH: Me neither. My eldest Jago's mad-keen though. He's just been made captain of his year which is quite a big deal at Sussex House, apparently. And he's wickie too so that's double the equipment. On top of which his mother's got him playing the cello. You should see him leaving for school. I always joke that we should have called him Sisyphus. *(Joke fails to find an audience.)* The second criteria we call 'V' or 'Best Verbal Response' and this is a scale of one to five. One point means no verbal

sound, five means fully coherent conversation. Sophie's made no verbal sound, has she?

JONAH: No.

SOPHIE: So that's one point again, which we add to the overall score.

JONAH: Making two.

SOPHIE/MR SHUTTLEWORTH: Leaving our final criteria, which is 'M' or 'Best Motor Response', which is now a one to six for some reason. So, it's one point for no motor response, six if she can obey simple commands. Squeeze the nail, see if she flinches.

JONAH squeezes SOPHIE's fingernail again.

SOPHIE/MR SHUTTLEWORTH: Bit harder.

He squeezes the nail again but to no avail.

SOPHIE/MR SHUTTLEWORTH: So, that's another 'one' which we add to the overall total…

JONAH: Making three.

SOPHIE/MR SHUTTLEWORTH: Which is her overall GCS.

JONAH: Could be worse.

SOPHIE/MR SHUTTLEWORTH: Not really, three's the minimum. But you're right to stay positive. And remember, just because she can't respond that doesn't mean it's not going in. So don't be shy about talking to her.

JONAH: What should I say?

SOPHIE/MR SHUTTLEWORTH: Read to her if you're stuck. It's just good for her to hear your voice.

JONAH picks up a newspaper and opens it.

JONAH: *(Reads.)* 'Most cat-owners will tell you kittens have two faces. A sleepy one and a hungry one. But a retired

Lincolnshire couple have an extra mouth to feed this weekend after a healthy kitten with an extra head was born.'

SOPHIE/HERBERT HARTWIG: My friend?

JONAH: 'He's been named Harvey Dent after the two-faced villain from the Batman comic-book series –

SOPHIE/HERBERT HARTWIG: My friend? *(JONAH looks up.)* I don't disturb you, I hope. My name is Herbert Hartwig. I was there when the accident took place. I telephoned the ambulance. Sophie's in a coma, yes?

JONAH: I'm afraid that's correct.

SOPHIE/HERBERT HARTWIG: May I sit down?

JONAH fetches a chair. Still attached to various tubes and wires, SOPHIE gets up to be HERBERT, sitting in the chair and facing the bed.

SOPHIE/HERBERT HARTWIG: May I ask, what is your name?

JONAH: Jonah.

SOPHIE/HERBERT HARTWIG: Hello, Jonah. *(They shake hands.)* I'm sure you can tell I'm from Germany. I fly back to Stuttgart this afternoon. I live in Heidelberg, which is fifty miles north-west of there. Last year my boyfriend died from a drugs overdose there. This is my first time inside a hospital since that day. In Germany they say the British hospital is a pile of shit but this one's not so terrible. *(They sit in silence for a few seconds.)* Do you know the Whitechapel Art Gallery, Jonah?

JONAH: No.

SOPHIE/HERBERT HARTWIG: I am an artist, I have currently an exhibition there. It's a shit exhibition, I don't like it. But I was going there to make an interview with a man called Simon Price. He is a journalist with one of your art magazines. But when I arrange this meeting I'm as drunk

as a skunk, so I forget about the meeting, so I receive a call on my cellphone saying 'Herbie, what the fuck?' So now I'm running to the Whitechapel Art Gallery from my shitty hotel to make this interview when I hear behind me this crash and there on the road is your Sophie. *(Carefully climbs back into the bed.)* But she'll be okay.

JONAH: What makes you say that?

SOPHIE/HERBERT HARTWIG: There is a noise you can listen for. Of death, as it hovers above the dying.

JONAH: Are you sure that's not just in Germany?

SOPHIE/HERBERT HARTWIG: No, in all places. Like a humming sound. But high. Like a wet finger round the edge of a glass. Can you hear it?

JONAH: No.

SOPHIE/HERBERT HARTWIG: Then this is good. This means she'll be okay. *(Holds out a business card as if from nowhere.)* These are my contact details.

JONAH: *(Takes card. Takes out a notebook and pen.)* Hospital days go slower than normal days. To pass the time, I keep a recovery diary, using the GCS. *(Writes in notebook.)* 'Day One: Three Points.' *(A day passes.)* 'Day Two:' Sophie? *(No response. Squeezes her finger. No response.)* 'Three Points.' *(A day passes.)* 'Day Three:' Sophie? *(No response. Squeezes her finger. No response.)* 'Three Points.' *(A day passes.)* 'Day Four:' Sophie? *(No response. Squeezes her finger. She gives a slight groan.)* Progress. 'Four Points.' *(A day passes.)* 'Day Five:' Sophie? *(No response. Squeezes her finger. Slight groan, other arm moves.)* Progress. 'Five Points.' *(A day passes.)* 'Day Six:' Sophie? *(No response. Squeezes her finger. Slight groan and other arm moves.)* For three days she remains on five points.

SOPHIE/MR SHUTTLEWORTH: The brain's like an egg. It'll hatch when it's ready.

JONAH: On Day Nine the groan becomes a mumble. *(Squeezes her finger. She mumbles.)* On Day Twelve her eyes half open and she speaks her first word. *(Squeezes finger.)*

SOPHIE: *(Eyes half open.)* Fuck.

JONAH: And then on Day Fourteen her eyes open fully. *(Squeezes finger. Eyes open fully.)* On Day Fifteen she smiles and the next day she speaks her first sentence.

SOPHIE: Can I have some water, please?

JONAH: *(Helps her to drink.)* And I'm there for every step.

SOPHIE: *(Sips through straw.)* He's attentive…to the point of… stifling.

JONAH: That's it.

SOPHIE: But without him… I think I'd be dead.

JONAH: I tell her I live in the flat beneath hers and on the day of the accident I heard her phone ringing. And something inside me, call it intuition, knew that something was wrong. So I kicked down the door, picked up the phone and spoke to Mr Shuttleworth, who said there'd been a terrible accident and that I should come quick.

SOPHIE: *(Sprays her hair with dry shampoo.)* I act like I buy this and tell him I own his flat…but nothing else.

He takes the dry shampoo and sprays her hair, taking over from her.

JONAH: Visiting hours finish at six, so this is when I go home. All except one evening when I go to Battersea Park to see Sussex House play the final of an inter-school cricket competition.

He massages the dry shampoo into her scalp…

JONAH: It's a warm evening and a nice occasion, with mums in bare feet drinking wine on big blankets, and dads in their jeans giving tips to their sons. Mr Shuttleworth's on a blanket with his wife Claire and their youngest Benedict.

He brushes the dry shampoo from her head, getting increasingly vigorous as he gets carried away with his story...

JONAH: Sussex House set a score of a hundred and nine, with Jago scoring ten. This looks to be enough until a large Indian child comes into bat and scores quickly. But on the second from last ball of the match, the large Indian child is out, making it one ball left and two runs to win. At which point an even larger Indian child comes into bat and we all fear the worst. The even larger Indian child hits the ball high into the air and starts to run. From his place behind the stumps, Jago runs to make the catch. And he's lightning quick but not quick enough, it seems, until he leaps like a fish and grabs the ball an inch from the grass. And his team-mates jump on top of him. And Mr Shuttleworth puts Jago on his shoulders. And behind my bush I celebrate too, clenching my fist and saying 'yes'.

SOPHIE: The physio team want me out of bed as soon as possible. They teach me a log roll for getting up, which goes like this. *(Performs the stages of log roll as she describes them.)* First I bring my knees up and fold my arms across my chest.

JONAH: *(Assists.)* Then, with one hand on her lower back and the other on her shoulder, I help her onto her side, keeping the back straight.

SOPHIE: *(With some help.)* Using my good hand I push up into a sitting position. Take a breath so I don't get dizzy.

JONAH: *(Helps her to stand.)* Then carefully up, using the arms for support.

As SOPHIE moves about on crutches, JONAH makes the bed.

SOPHIE: *(Painful, slow.)* The next stage of the recovery process...is slow. My short-term memory's quite poor...so I do exercises for that. And if I try and draw something... even something easy like a face or a house...it looks like a baby drew it. As far as getting about goes... I do a bit more each day. And my short-term memory's quite poor...so I

do exercises for that. Until finally…after eleven weeks and four days…

SOPHIE arrives in the garden at home. Her bed is on the lawn with Winston on the pillow. There is a bedside table with fizzy water and a lamp. The sun shines on clean white sheets. Birds are singing, bees are buzzing, a gentle breeze is blowing.

SOPHIE: …oh my God.

JONAH: Are you pleased? I thought you'd be pleased, do you like it?

SOPHIE: How did you even…?

JONAH: Get it downstairs?

SOPHIE: Know? How did you know?

JONAH: You told me, don't you remember? You said it's what your father did. When you had your teeth removed. So I thought you might like the same again. So, are you pleased? I thought you'd be pleased.

SOPHIE: Really pleased. Just a bit overwhelmed.

JONAH: With happiness though?

SOPHIE: Sorry?

JONAH: I knew you would be. I even did the lamp and fizzy water, look. So is it the same?

SOPHIE: Pretty much.

JONAH: Been planning it for ages.

SOPHIE: You must have been.

JONAH: I knew you'd be pleased. I thought it might rain but luckily it hasn't. So, are you going to get in or just stand there looking at it?

SOPHIE: Okay.

JONAH: I'll help.

SOPHIE: No, I can do it.

JONAH: I don't mind.

SOPHIE: No, just let me.

JONAH: Well, I'm here if you need me.

SOPHIE sits on the edge of the bed.

JONAH: Deep breath first.

She takes a deep breath.

JONAH: Cross your arms.

She crosses her arms in front of her and lies on her side.

SOPHIE: Shit, I'm stuck.

JONAH: Okay.

SOPHIE: It's different, why's it different?

JONAH: You're okay.

SOPHIE: I'll come back up.

JONAH: No need, I can roll you from there.

SOPHIE: Don't.

JONAH: *(Moves to help.)* I can roll you, it's fine.

SOPHIE: Please just get off me, I want to come back up.

JONAH: Okay.

He stands back and she comes back up to a sitting position.

SOPHIE: Sorry, it just feels different somehow. It's lower than the hospital bed.

JONAH: All the time in the world.

She takes a deep breath and crosses her arms in front of her.

JONAH: I think if you shuffle that way, just half a bum-width…

She moves half a bum-width up the bed, takes a deep breath, crosses her arms in front of her and this time manages to get onto her back. She wriggles up the bed into a sitting position.

JONAH: So, are you pleased?

SOPHIE: It's lovely.

JONAH: Must be, after all those weeks indoors. Thought it might rain.

SOPHIE: I wouldn't have minded.

JONAH: Not if it rained this morning though. Climbing into a wet bed, lying on wet sheets. Twenty per cent the forecast said, chance of showers.

No one speaks.

JONAH: So can you feel your lungs getting cleaner?

SOPHIE: It's a bit like that.

JONAH: And your blood cells being revitalised? Have some fizzy water if you like.

SOPHIE: Not just now. Don't want to keep needing the toilet.

JONAH: You've got to keep hydrated though.

SOPHIE: I'll have some in a bit.

JONAH: Well, it's there if you need it. *(No one speaks.)* I'll pour some anyway, shall I? Then it won't be too fizzy when you do want it. And if you want it more fizzy then I can always pour you a fresh one. *(He pours a glass of fizzy water.)* You don't have to do anything, that's the rule. Whatever needs doing, I shall do it. *(He produces a lemon and a knife from a drawer and cuts a slice.)*

SOPHIE: I can do some things.

JONAH: But you don't have to's what I'm saying.

SOPHIE: To get stronger I do. They said to do as much as I can.

JONAH: Within reason.

SOPHIE: *(Snaps.)* Well, obviously within reason. *(JONAH is dented.)* I'm sorry, I'm just freaked out being away from the hospital.

JONAH: This is what I'm saying, I'll look after you.

SOPHIE: I know you will. You've been amazing.

JONAH: I can leave you to sleep if you're tired.

SOPHIE: I'm fine. Thanks for this, it was a really kind thing to do.

JONAH: I'd like to say it was easy but it wasn't. I thought I could carry it down in three or four pieces. But unless you remove the bars that hold the mattress the main section's too big. I had to dismantle it completely in the end. Then when I put it back together it made squawking noises for some reason. Did it make squawking noises before?

SOPHIE: I'm sorry, what?

JONAH: Did it squawk before, the bed, when you lay on it?

SOPHIE: Maybe.

JONAH: I ended up buying rubber washers. The big ones meant for shower heads? I bought twenty-four of those and put one each end of each bar –

SOPHIE: Actually, Jonah, stop a minute. There's something I need to say.

JONAH: Okay.

SOPHIE: It's about you following me.

JONAH: Eh, what are you talking about?

SOPHIE: It's about you watching me. At home and round London.

JONAH: What are you talking about? I don't know what you mean.

SOPHIE: I thought maybe we could just pretend it never happened –

JONAH: Pretend what never happened?

SOPHIE: …but it's not going to work.

JONAH: What won't work? What are you even talking about?

SOPHIE: This won't work. Us. Unless we're up front.

JONAH: About what though?

SOPHIE: How we know each other. How you came to be in the hospital –

JONAH: I told you this. I heard your phone and broke the door down.

SOPHIE: The screen was from me. I sent you the screen.

JONAH: Why would you do that?

SOPHIE: Because I thought it might feel good. Who did you think it was from? You must have wondered.

JONAH: Not specially, no. So all that time? Even on The London Eye?

SOPHIE: It doesn't have to be that big a deal.

JONAH: I feel ashamed.

SOPHIE: Why should you feel ashamed?

JONAH: I don't know, perhaps because I've been caught displaying the behaviours of a pervert.

SOPHIE: I'm the one that made it happen. Can't we just draw a line?

JONAH: I'm not sure I believe in drawing lines.

SOPHIE: Why not? Let's just make this a new beginning.

JONAH: I'm not sure there's such thing as a new beginning.

SOPHIE: Of course there is. Look around you, look at the sky.

JONAH: I don't want to look at the sky.

SOPHIE: Then look round the garden.

JONAH: What's the sky got to do with anything?

SOPHIE: All the birds and beetles.

JONAH: What are you on about, birds and beetles?

SOPHIE: I'm saying we could be at the start of something here.
 If we want to be.

JONAH: It's autumn, not spring, everything's dying.

 Unhappy silence.

SOPHIE: I don't think it's embarrassing. I think it's funny.

 JONAH is unconvinced. SOPHIE takes a stone from her pocket.

SOPHIE: Did I show you this? Jonah, did I show you this?

JONAH: *(Won't look.)* Show me what?

SOPHIE: It's a stone.

JONAH: Why would you show me a stone?

SOPHIE: Because it's magic. *(JONAH scoffs.)* It's true, it's got
 healing powers, come and look.

JONAH: No, thank you. I don't believe in stones with magic
 powers.

SOPHIE: Come and look then, I'll prove it.

 *Reluctantly, JONAH joins SOPHIE on the bed. She gives him the
 stone and the knife.*

SOPHIE: Okay, make a scratch in the stone with the knife. Go on.

JONAH makes a scratch with the knife.

SOPHIE: Okay, now rub the scratch with your thumb.

JONAH: Why?

SOPHIE: Just do it.

JONAH rubs the stone.

JONAH: This is fun.

SOPHIE: It's worth it, I promise. Keep rubbing. *(He rubs some more.)* Now look. *(He looks.)* See? The scratch is gone.

JONAH: That's weird. Who told you it could do that?

SOPHIE: It came with a tiny booklet. It's called hematite. Hold it against your forehead.

JONAH: Why, what does that do?

SOPHIE: Feels good. *(She holds the stone against JONAH's forehead.)* Draws out everything bad.

They kiss. As the kiss ends, they become aware of the audience. They seem slightly embarrassed, as if they performed more of the scene than they had intended.

JONAH: I move in upstairs and turn downstairs into a kind of rehab zone, with soft blue mats on the floor and wipeable charts on the wall.

SOPHIE: I do an hour of physio in the morning and another in the evening, plus an hour of cognitive stuff. And the rest of the time we just get on with normal life, don't we?

JONAH: Develop small routines.

SOPHIE: Nothing all that unusual. Just normal couply stuff, I guess. Certain meals we like to cook.

JONAH: Things we like to watch on television.

SOPHIE: Who does what housework, that kind of thing.

JONAH: Who sleeps what side of the bed.

SOPHIE: Sex is kind of scary at first. I find it hard to relax and get comfortable. And hard to trust my pelvis. But I speak to my physio, and she gives me advice on positions, and after a few more times it becomes kind of fun. More than fun, actually, kind of joyous. And the fact it's a new thing for both of us makes it all the more special somehow.

JONAH: I get a part-time job delivering parcels. And I develop a fascination with supermarket shopping. Making a shopping list and buying what's on it. Then bringing those things home to the girl with whom I'm in a relationship.

SOPHIE: It's basically just a really happy time.

JONAH: Scruffilitis shows signs of improving health, with new hairs sprouting from his baldy patch.

SOPHIE: We even get a visit from Jonah's dad, don't we?

JONAH: I think he's come to take me away, but quite a lot's changed in Paythorne since I left. He says an unsuccessful attempt to fall in love with Mrs Dimmock's left him with more questions than answers with regard to the meaning of life. And then he suggests we switch on the television.

SOPHIE: It's the episode where Andrew and Summer finally get together. She says she's going to live with her aunt in Bendigo. But Andrew chases the car and begs her to stay. We sit three across on the sofa, welling up with tears.

JONAH: And then, as he's leaving, my father hands me a plastic bag, containing the old welly boots I showed you.

SOPHIE: I email Herbert, the artist, to thank him for calling the ambulance and coming to visit. He writes back and tells me about an exhibition he wants to create. He wants to build a pretend MRI scanner that you can slide a person into, and inside there's a miniature exhibition about my accident. With bits of sound and video and pictures to

look at. And he wants me to record myself saying what I remember, not just of the accident, but everything. Coming out of the coma, the whole recovery process. And he wants me to take photos of my scars once a week, to show the gradual change from red to white. *(Puts on her dad's old green overcoat.)* So I do. I start sending him sound files. And jpegs of my injuries.

JONAH: I pay Mr Shuttleworth a visit at home. I have his address from a used envelope upon which he drew a diagram of Sophie's fractured pelvis. He's surprised to see me at first, but he invites me in and Claire, his wife, brings me a glass of beer. His youngest, Benedict, is in the corner, making a soap-powered boat, which is a boat that's totally powered by soap. And in the next room Jago's practising his cello, which he does every Tuesday apparently.

SOPHIE: I get invited to the exhibition opening. It's in Zagreb in Croatia, but I don't go. I'm not really up to the travel.

JONAH: I visit again the following Tuesday, but it's a shorter visit this time, with squash instead of beer.

SOPHIE: But also, it doesn't feel necessary somehow. Because even though it's thousands of miles I can still feel the people looking. And it's a good feeling. So much that when it's over it's like it leaves a hole. Soon to be filled by that fir cone feeling. *(She stares at her hand and the arm of the coat.)* Herbert sends my dad's old coat in the post by way of thanks.

JONAH: The following Tuesday I go again to Mr Shuttleworth's but he keeps me on the doorstep this time. And after a short conversation he goes back inside. But it's a warm evening so I stand on the pavement, listen to Jago's cello practice from there. And it's a beautiful sound, so I come back the next week and do the same, and the week after. And every week until a police lady comes by. Says there's been a complaint and I shouldn't come again.

Deep breath.

SOPHIE: Jonah moves back in downstairs. It just works better this way somehow. For both of us. So Jonah moves back in downstairs.

Deep breath.

JONAH: I put the blue mats on their sides behind the shed and move back in downstairs. Become friends with the screen again.

SOPHIE: My recovery continues okay. Except the bones in the middle of my foot set wrong, like Sophie Cattermole's, so walking's painful. Plus I start having these mini-seizures once a week.

JONAH: When these happen I look away. It's why doctors prefer the word 'rehabilitation' to 'recovery'. Does less to suggest you'll ever be totally fixed.

He watches her in silence for a moment.

JONAH: Love is whatever you feel it to be.

SOPHIE: We don't completely ignore each other. If we see each other in the street we say 'hello'.

JONAH: She joins me in the garden when I bury Scruffilitio.

SOPHIE: *(Sits with a book.)* But apart from that it's pretty much back to before. Just knowing he's there.

JONAH: Sitting in the quiet, watching her as she sits and reads a book.

She turns a page.

JONAH: Turns a page.

She shifts in her seat.

JONAH: Shifts in her seat.

She scratches her ankle.

JONAH: Scratches her ankle.

She pushes her head to one side to loosen her neck.

JONAH: Pushes her head to one side to loosen her neck.

She continues to read in silence. She looks up from her book for a moment. She looks back at her book and reads some more.

End.

OTHER PHIL PORTER TITLES

The Cracks in My Skin
9781840028348

Starseeker
9781840027938

Stealing Sweets and Punching People
9781840024043

Porter: Two Plays for Young People
The Flying Machine
Smashed Eggs
9781840028645

WWW.OBERONBOOKS.COM

 Follow us on www.twitter.com/@oberonbooks
& www.facebook.com/oberonbook